Mostly Durham

Watercolour Paintings and Drawings of Durham and Beyond

— STUART FISHER —

Sacristy
Press

Sacristy Press
PO Box 612, Durham, DH1 9HT

www.sacristy.co.uk

First published in 2015 by Sacristy Press, Durham

Written and designed by Stuart Fisher

Sacristy Limited, registered in England & Wales, number 7565667

British Library Cataloguing-in-Publication Data
A catalogue record for the book is available from the British Library

ISBN 978-1-910519-06-6

To my wife, Anne.

Preface

Mostly Durham contains a selection of work produced over a period of about fourteen years. These paintings, as the title suggests, are mostly, but not exclusively, views of Durham City and its Cathedral. It was many years before I was able to bring myself to explore the possibilities offered by the city's ancient architecture, and it was only my long-standing friendship with the renowned architectural photographer Royston Thomas, whose black sky images I much admired, that finally led me to take up the challenge.

Indeed, photographs in the form of hastily-taken holiday snaps form the basis of most of my paintings, much to the satisfaction of my long-suffering wife who has, on more than one occasion, almost burned to a crisp whilst I slave over yet another *plein-air* production.

All images are reproduced from photographs of the original works taken over a period of years and with a variety of equipment. As such, there is a natural variation in photographic quality. Some of the images are lacking signatures due to the process of cropping.

Stuart Fisher
Peterlee, County Durham, Spring 2015

Foreword

I am delighted to introduce this exquisite book.

Unusually, this gallery of paintings and drawings has its origins in photography. As a photographer myself, I wasn't at all convinced that the photographic image translated happily into drawing or painting. The techniques seemed too different: we have all seen how good photographs can too easily become lifeless or undistinguished when transferred to a canvas or sketch pad.

However, this book has changed my mind—when the artist knows what he or she is doing and has the talent to go with it. Stuart Fisher is one of these artists. We have been delighted to welcome him when he has exhibited in Durham Cathedral from time to time. I have enjoyed getting to know his work and seeing how his artist's eye and instinct move naturally from one medium to another.

The results are effective, convincing, and beautiful. He captures the landscapes and heritage that belong to his native County Durham as well as to locations further afield in Britain and Europe. You will respond to the strong sense of place that draws Stuart into the subjects of his art. You will recognise his affection for—indeed, his love of—the locations he depicts. This essential genuineness of his art helps us to appreciate the subjects in new ways for ourselves.

As I contemplate my retirement as Dean, Stuart's book will be a little *vade mecum* of the Cathedral and County Durham to help me treasure precious memories of the past twelve years.

Michael Sadgrove
Durham Cathedral, The Feast of the Venerable Bede 2015

Contents

Durham City

The Great North Door ..2

Sunlight on Snow ..3

Castle Entrance after Snowfall ..4

The Castle Gatehouse ...5

Cathedral from Court Lane ...6

Sunshine after Showers ...7

On Owengate ...8

The Blue Door ...9

The Rose Window ... 10

Durham Market Place ... 11

The Castle Keep .. 12

The Castle Gatehouse and Keep 13

Elvet Bridge .. 14

The College Gatehouse ... 15

Summer Shadows .. 16

As Light Fades .. 17

The Cathedral at Dusk from Palace Green 18

The Cathedral's West Towers from College Green 19

The North Porch ... 20

The Water Tower in The College 21

The Count's House, Durham Riverside 22

The Cathedral from Palace Green 23

The Slipway, Durham Riverside 24

The Great Central Tower .. 25

College Gate .. 25

St Oswald's Church .. 26

The Cathedral in Winter .. 27

The Castle Gatehouse ... 27

The Cathedral from the Castle Entrance 27

The Sanctuary Knocker .. 28

Cathedral from Palace Green ... 29

Cathedral from Owengate .. 30

Moonlight and Snowfall ... 31

Crook Hall .. 32

Secret Retreat ... 33

Kingsgate Bridge .. 35

The Rose Window ... 36

Elvet Bridge .. 37

University Library ... 38

The Arched Gateway to The College 39

North Bailey Looking South ... 40

University Buildings on Palace Green 41

More Than Shadows ... 42

The Nine Altars .. 43

The College ... 44

University Library Buildings, Bay Window Detail 45

Out and About

St Mary's Church, Horden: "The Miners' Cathedral" 47

Pine Woods after Snow ... 48

Repose ... 49

Glade ... 50

Old Man of the Woods .. 51

Richmond Market Place, North Yorkshire................ 52

Richmond Castle .. 53

The West Door of York Minster............................... 54

And Day Became Night ... 55

The Collector's Retreat ... 56

The Outer Quad of Jesus College, Oxford................. 57

The Clarendon Building, Oxford............................. 58

The Sheldonian, Oxford.. 59

The Queen's College, Oxford................................... 60

Batheaston Toll Bridge.. 61

Pulteney Bridge, Bath .. 62

HMS Warrior .. 63

HMS Victory.. 64

Cornish Goodies... 65

Further Afield

The Church of Santa Maria Misericordia, Venice 67

Venetian Serenade .. 68

Gondola Stations ... 69

Palazzo on a Venetian Canal.................................... 70

A Street in Rome.. 71

The Church of Santa Maria Assunta, Venice 72

The Gondola Station .. 73

Basilica Santa Maria Salute, Venice.......................... 74

Roman Oasis ... 75

Durham City

Images of Durham's historic heart.

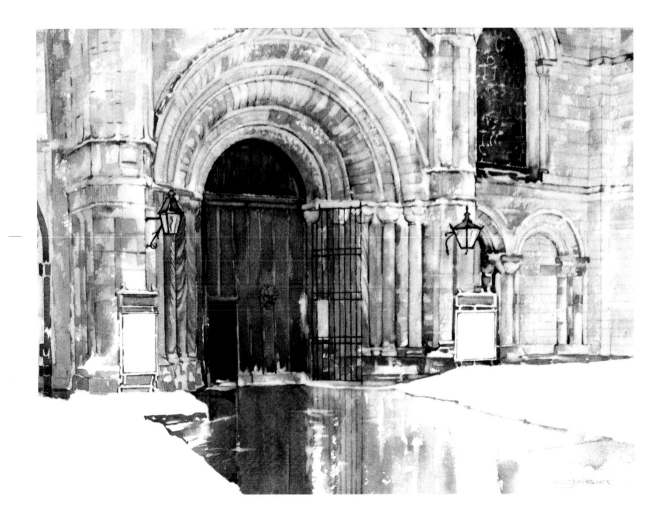

The Great North Door

The frozen stones of the Cathedral entrance and pavement, recently cleared of snow, reflect the sombre colours of winter.

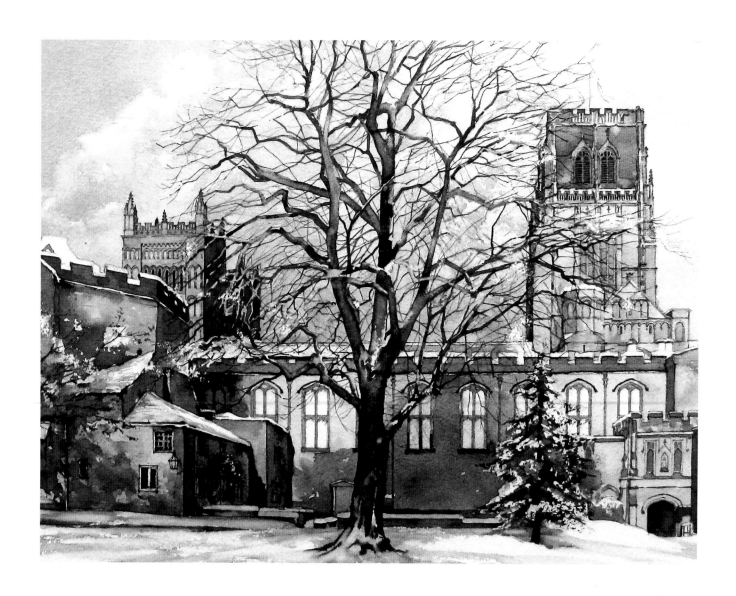

Sunlight on Snow
The Cathedral on a glittering winter's day, as viewed from The College.

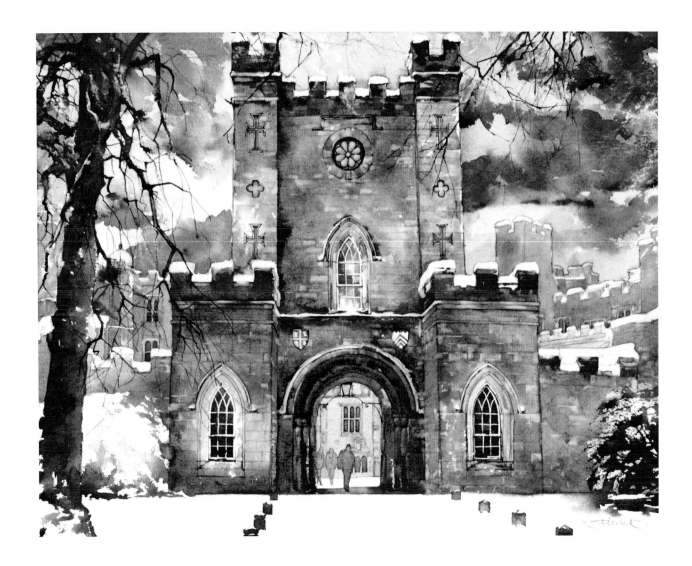

Castle Entrance after Snowfall
The entrance to the Castle under a fresh covering of snow.

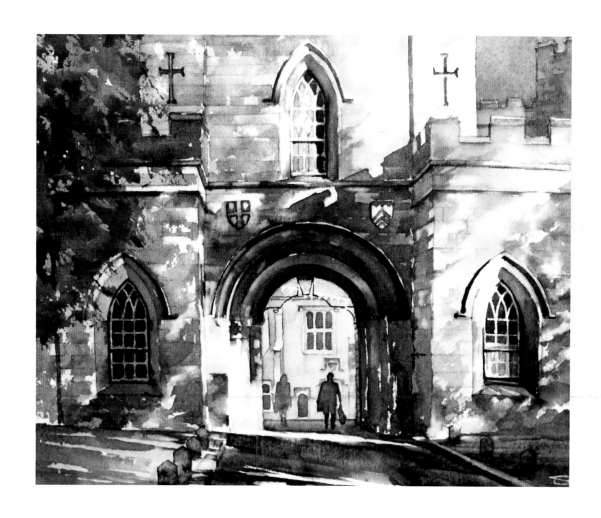

The Castle Gatehouse
Here seen in autumn light.

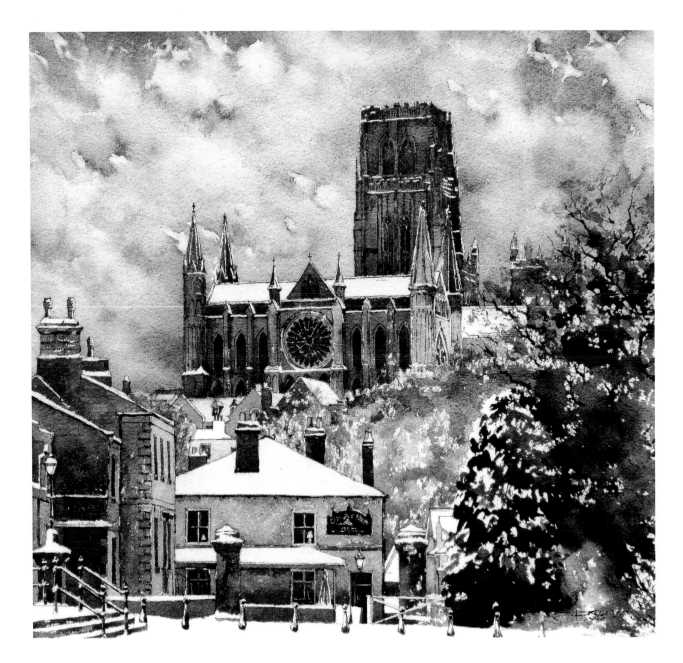

Cathedral from Court Lane

Here the majestic Cathedral looms high over the city.

6

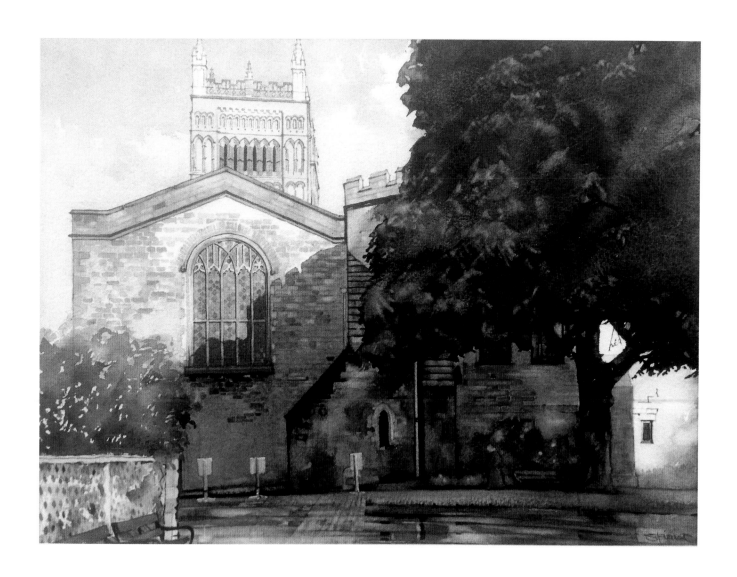

Sunshine after Showers

The south-west tower of the Cathedral, as seen from The College.

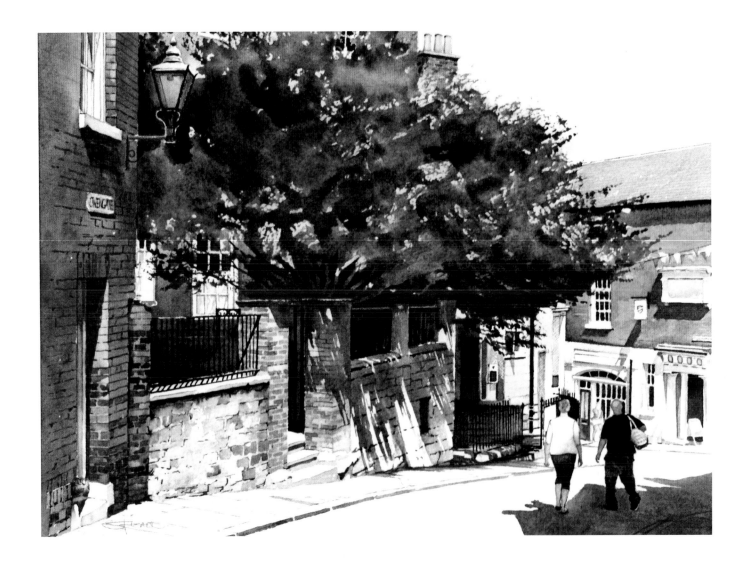

On Owengate

The principal route to Palace Green and the Cathedral for vehicular and foot traffic.

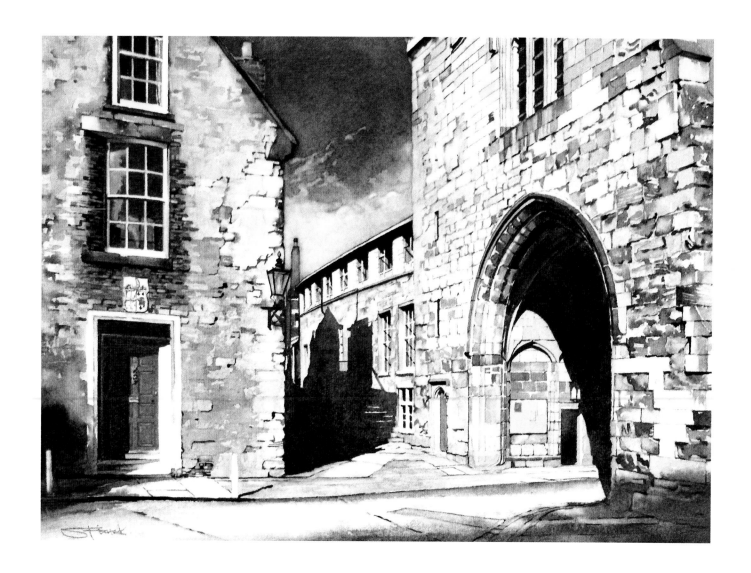

The Blue Door

The arched gatehouse on the right is the principal access for visitors to and residents of The College. The passage in the centre of the painting leads to the Chapter Office and workshops. The blue door leads to the residence of the Chapter Clerk.

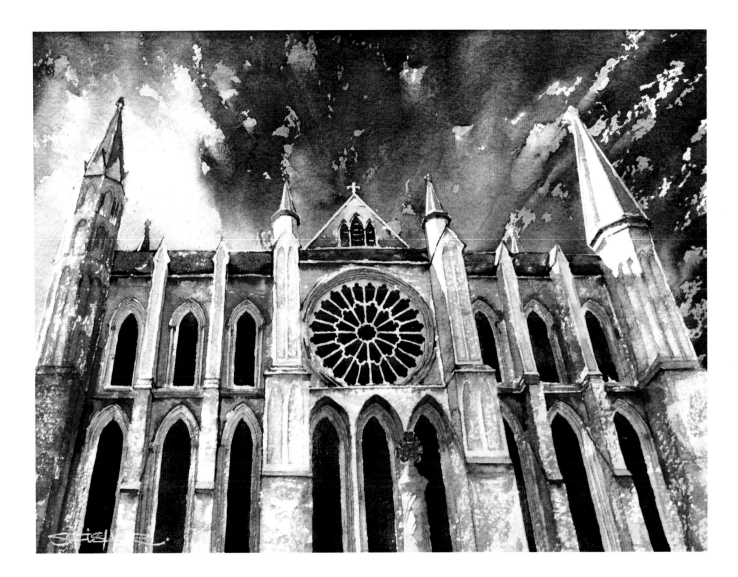

The Rose Window
The original thirteenth-century window was replaced by the architect James Wyatt in the eighteenth century. Wyatt was famous—
if not infamous—as the architect of William Beckford's Gothic confection, Fonthill Abbey, which collapsed in December 1825.

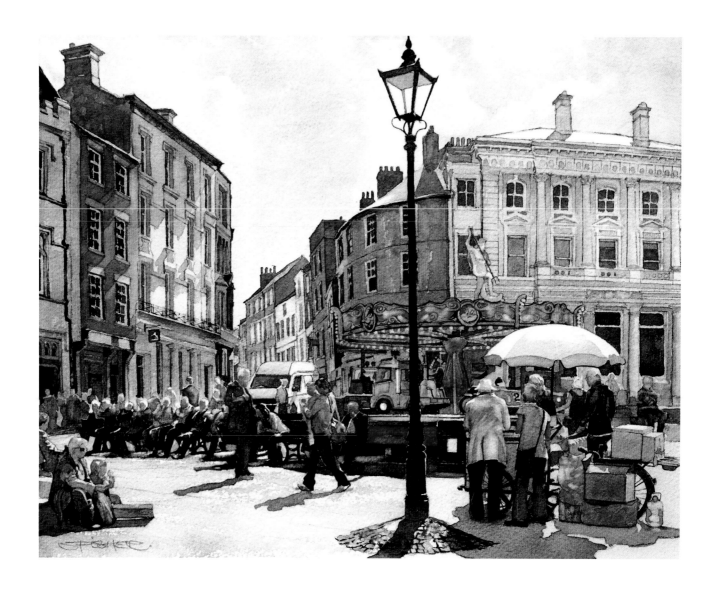

Durham Market Place

A gathering point for many visitors to the city, it is seen here prior to a significant makeover which was completed in 2011.

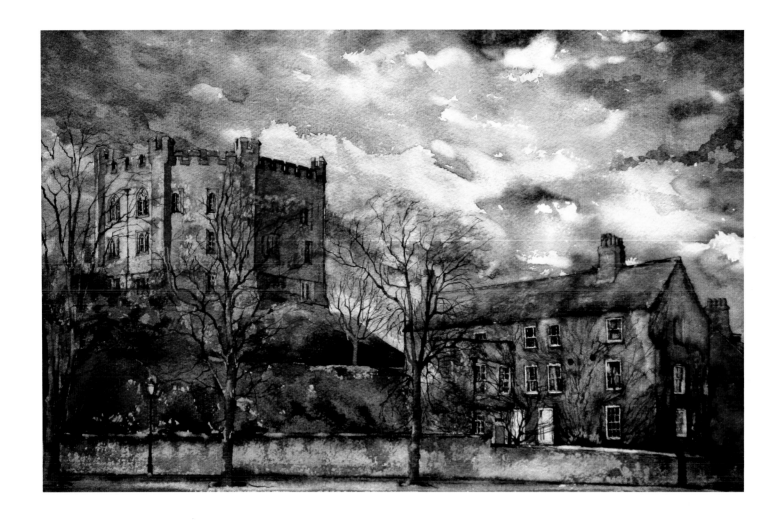

The Castle Keep
The fourteenth-century octagonal keep, which was substantially rebuilt in 1840, faces the Cathedral across Palace Green. The Master's House is on the right.

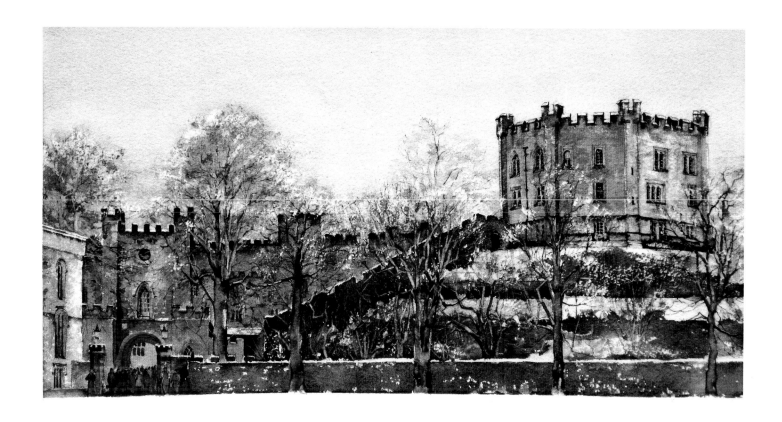

The Castle Gatehouse and Keep
Here shown on a bitterly cold winter's day.

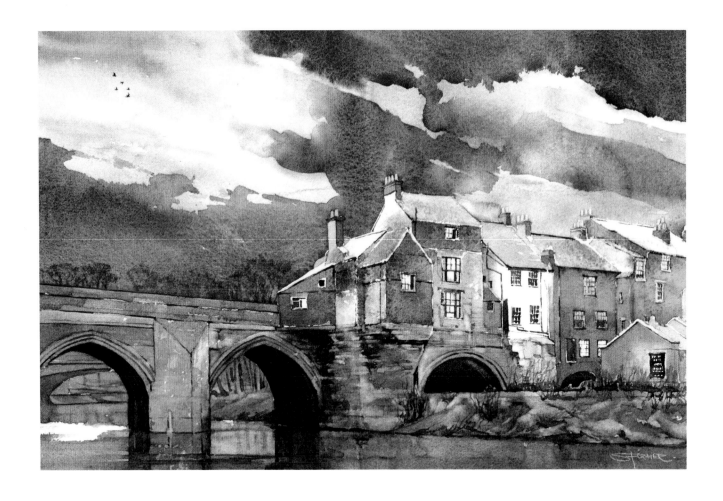

Elvet Bridge
Built sometime between 1170 and 1195, this is Durham's second oldest bridge.

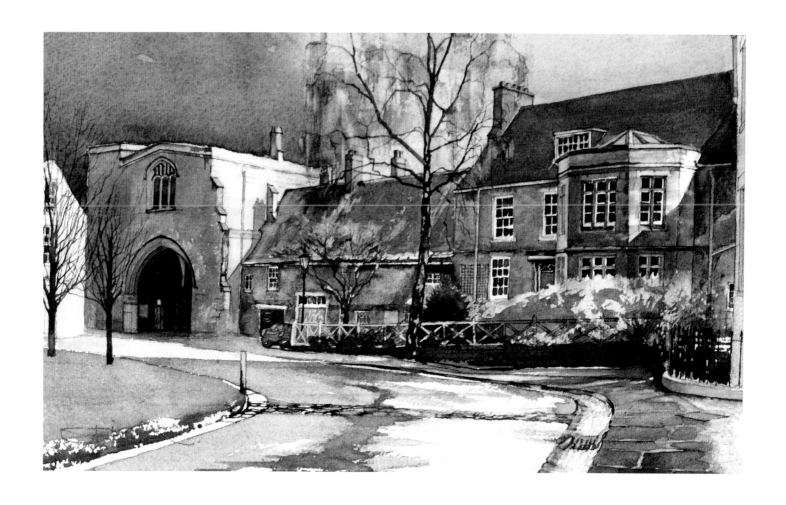

The College Gatehouse

Frost still clings to the road and pavements within The College precinct, an area behind the Cathedral which is often overlooked by tourists.

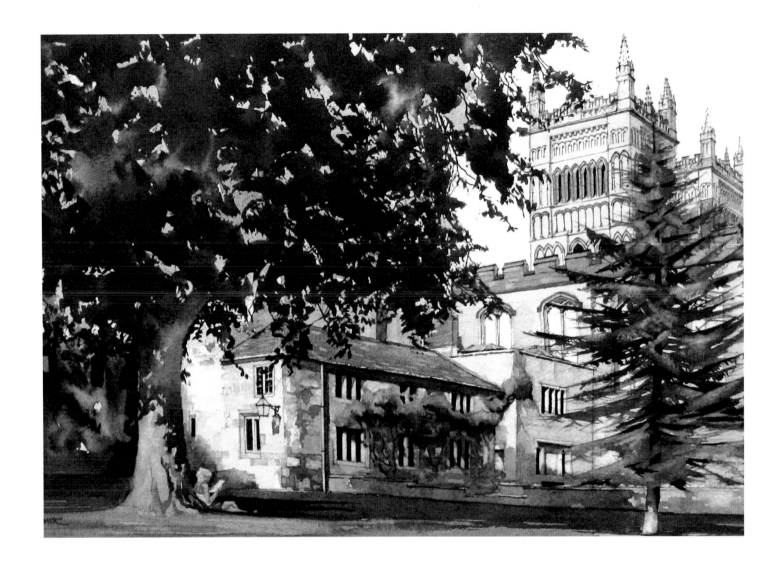

Summer Shadows

A relaxing afternoon on College Green.

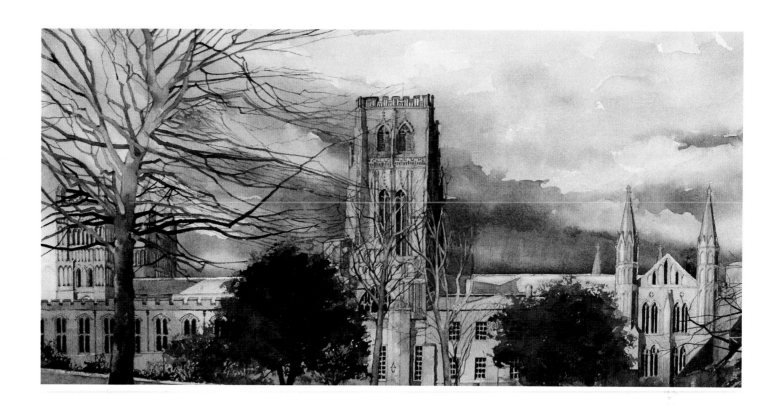

As Light Fades
The full splendour of the Cathedral's south elevation, as seen from The College, bathed in evening light.

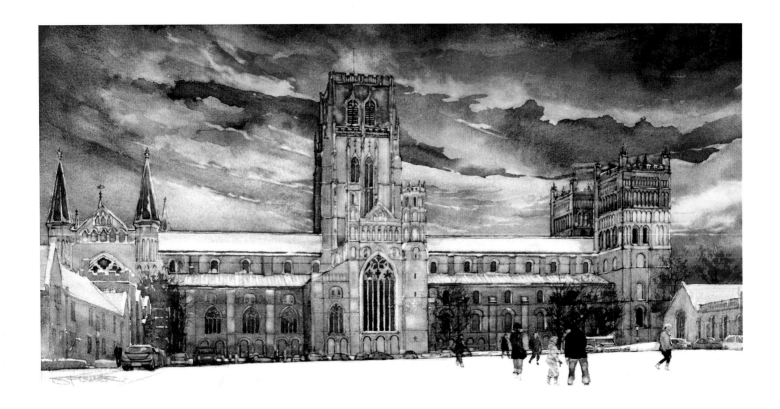

The Cathedral at Dusk from Palace Green

Visitors linger on the snow-covered green as light fades.

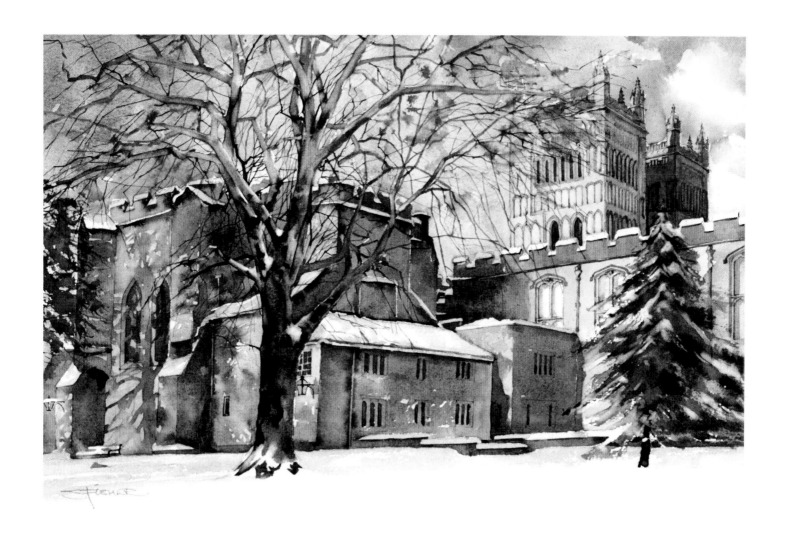

The Cathedral's West Towers from College Green
A winter view of the Cathedral, frequently missed by tourists.

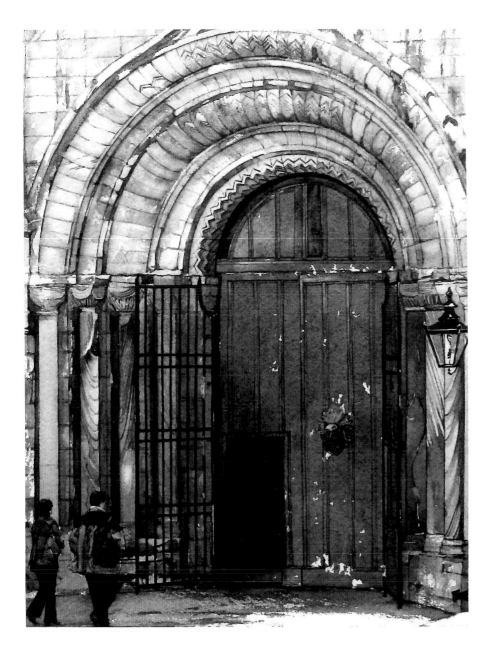

The North Porch
*The Sanctuary Knocker can be seen here on
the northern entrance to the Cathedral.*

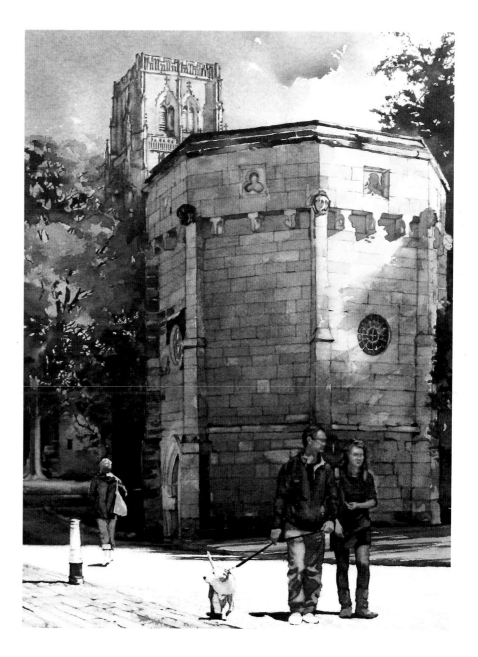

The Water Tower in The College

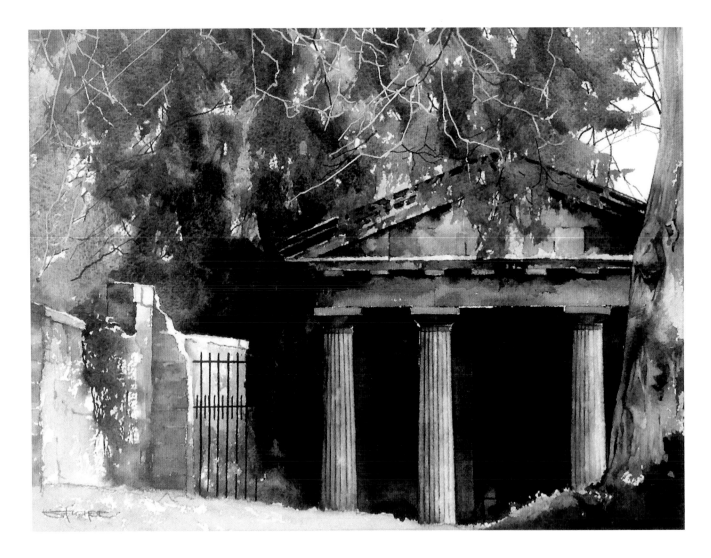

The Count's House, Durham Riverside
This folly once belonged to Polish-born "Count" Joseph Boruwlaski (1739–1837), a dwarf musician who entertained much of the European aristocracy in his lifetime. He ended his days in Durham City and was buried in the Cathedral. A life-size statue of him with various personal effects is kept in the Town Hall.

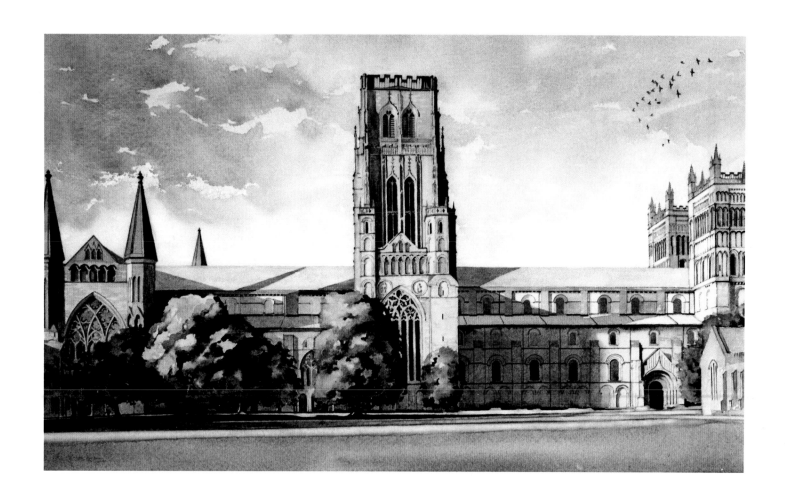

The Cathedral from Palace Green
Here seen with early morning light falling on the north face of the monument, whilst pigeons, just released from their lofts somewhere in the city, fly overhead.

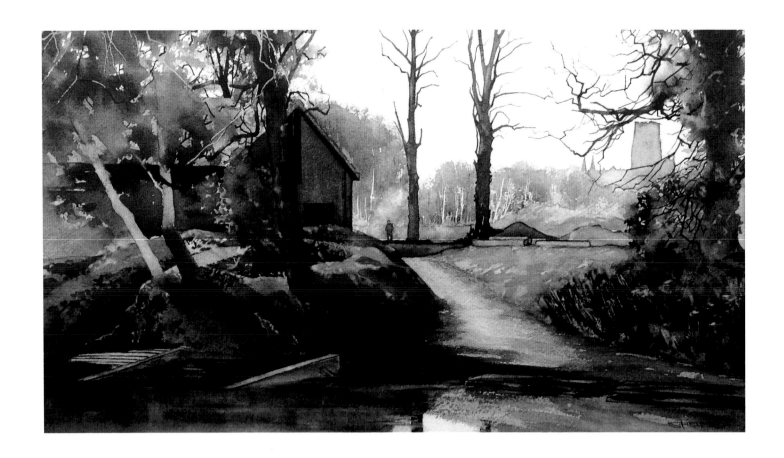

The Slipway, Durham Riverside
The River Wear slides slowly by the rowing club pontoons, whilst woodsmoke curls upwards from burning logs.

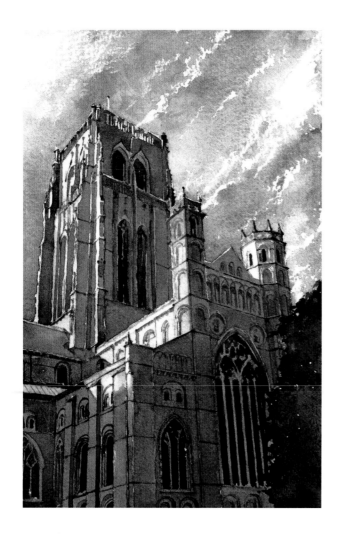

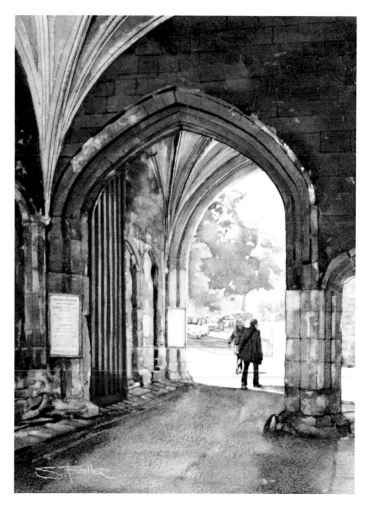

The Great Central Tower
An inspirational sight as high clouds streak overhead.

College Gate
Looking through into The College.

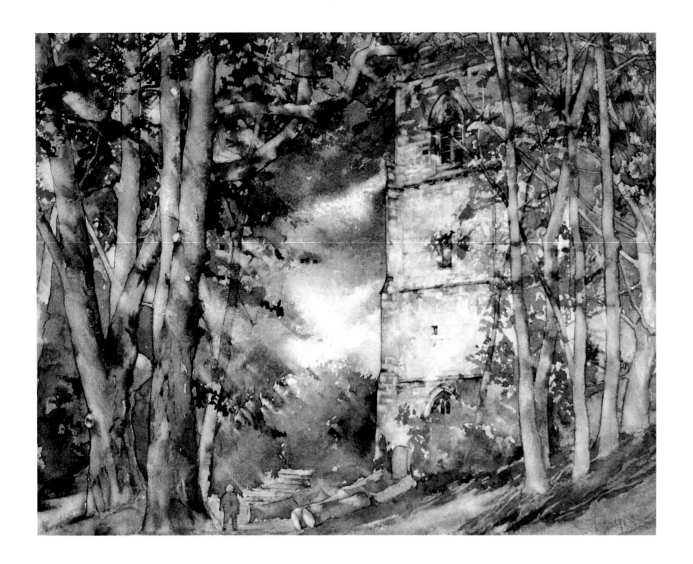

St Oswald's Church
This church occupies a site across the River Wear from the Cathedral.

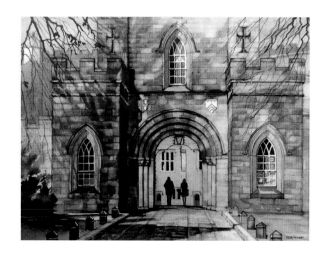

The Castle Gatehouse

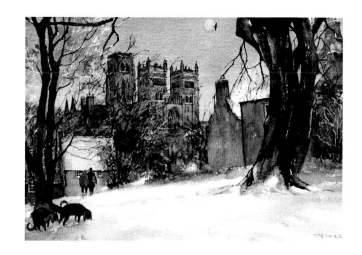

The Cathedral in Winter
*This painting borrows heavily from "Hunters in the Snow"
by the sixteenth-century Dutch painter Pieter Bruegel.*

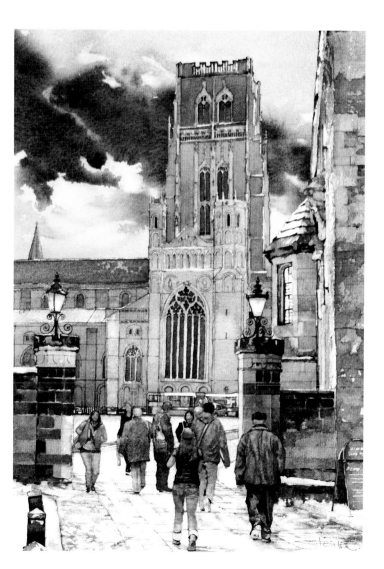

The Cathedral from the Castle Entrance

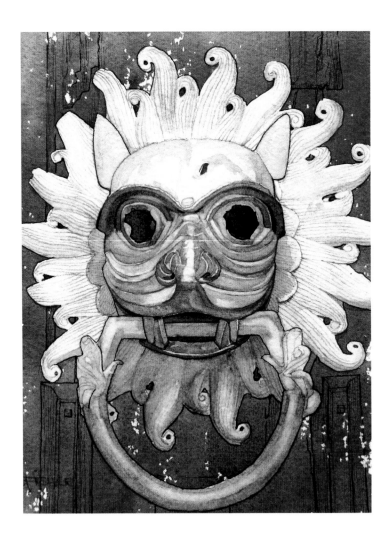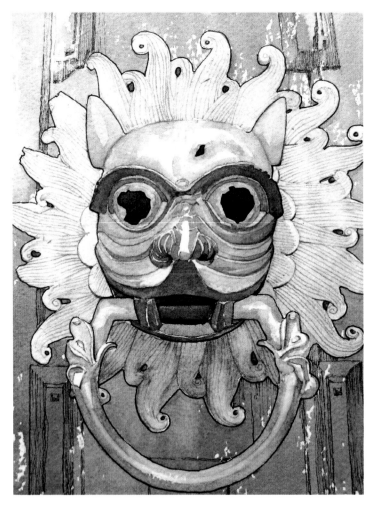

The Sanctuary Knocker
The knocker shown in place on the Cathedral's north door, an exact replica of the
original, which is normally on permanent display in the Cathedral.

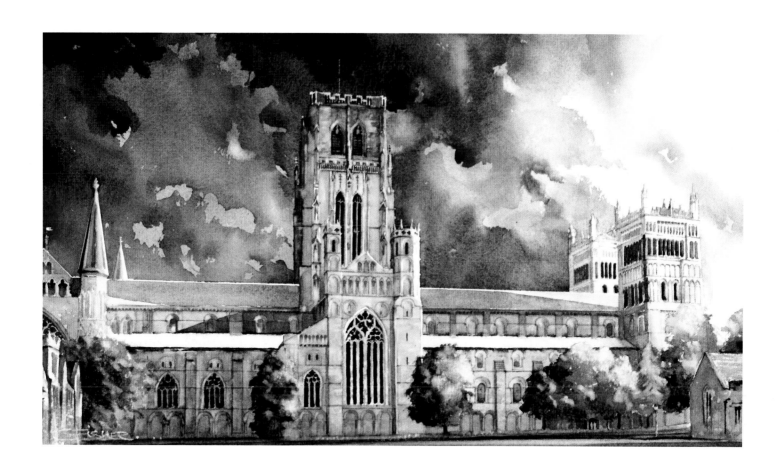

Cathedral from Palace Green
The turbulent sky gives the Cathedral a brooding presence.

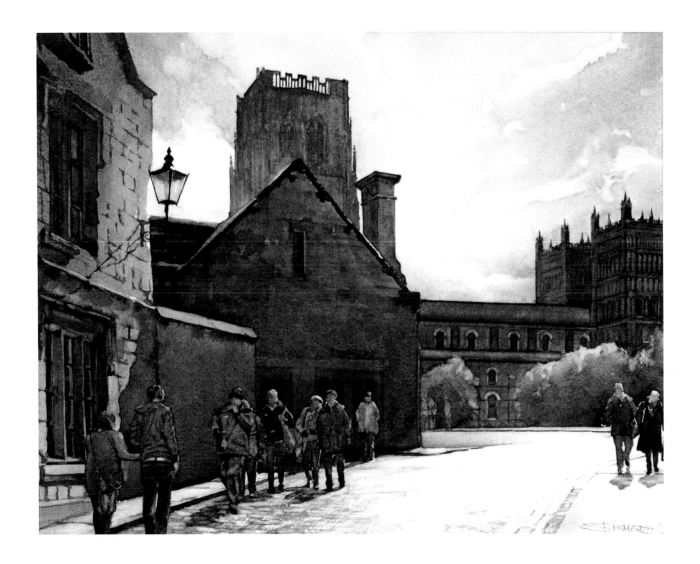

Cathedral from Owengate
The steep access up Owengate offers the visitor a first glimpse of the majestic Cathedral.

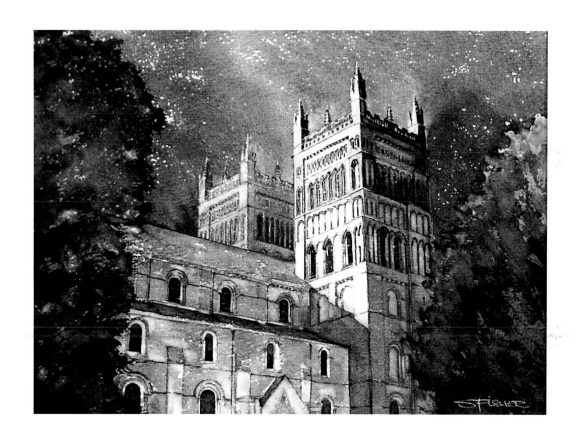

Moonlight and Snowfall
Snow flurries, illuminated by the moon, give the Cathedral a fairy-tale appearance.

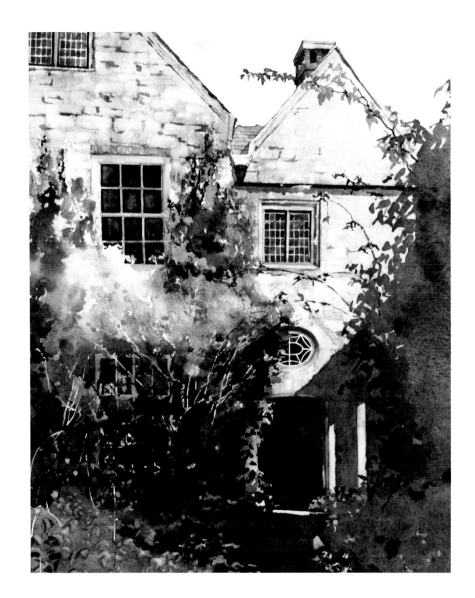

Crook Hall
This painting features the garden entrance to the original medieval hall, which is in constant use for weddings throughout the year.

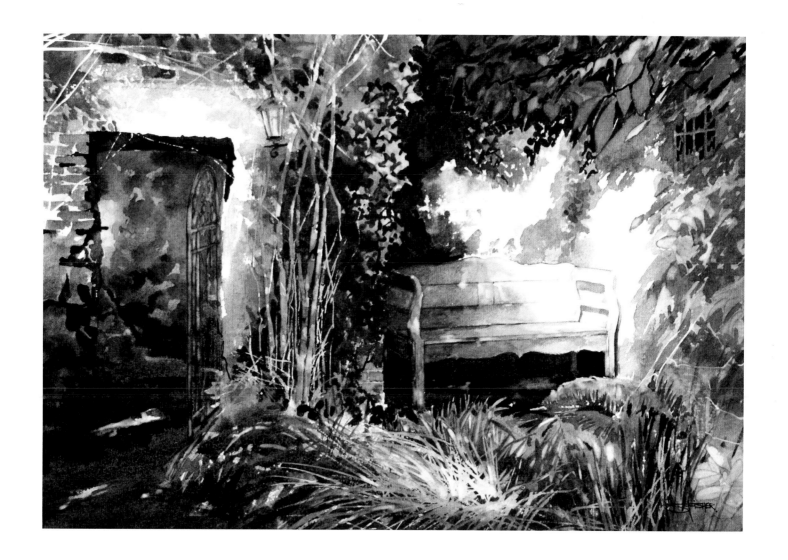

Secret Retreat
One of the many garden rooms in Crook Hall.

I have, over the last few years, taken a great interest in collecting etchings from the late nineteenth and early twentieth century. At that time, the etchings of Durham-born artist Albany Howarth, as well as those by the internationally-famous etchers Hedley Fitton and Frank Brangwyn, were considered to be blue-chip investments. However, two world wars resulted in their popularity disappearing, together with the hard-earned cash of enthusiastic investors.

The drawings and sepia-over-black ink paintings which follow are therefore in direct consequence of my interest in these images, and, although each is unique, as opposed to the multiple prints produced in etching, they are offered in celebration of that "lost art".

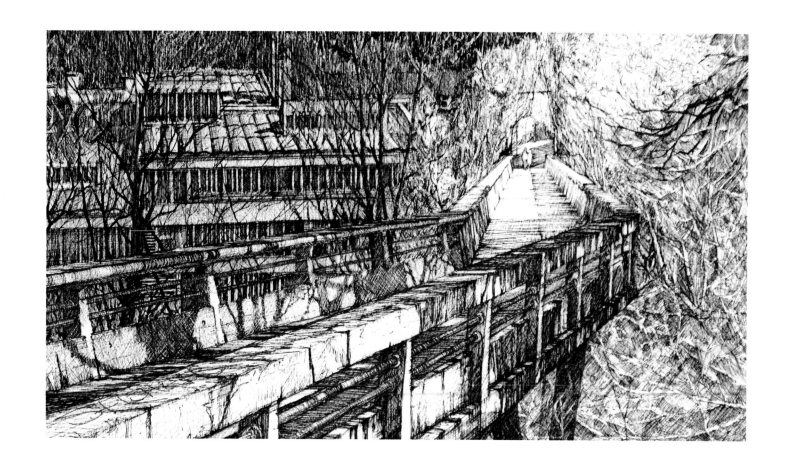

Kingsgate Bridge

This Grade I listed reinforced concrete bridge spanning the River Wear was designed by Ove Arup and opened in 1963.
Dunelm House, the centre for many Durham Students' Union activities, is seen to the left of the drawing.

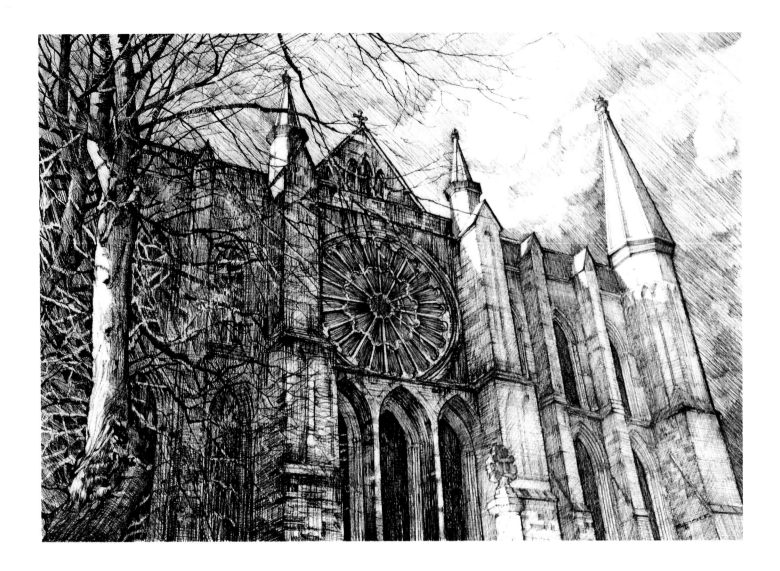

The Rose Window

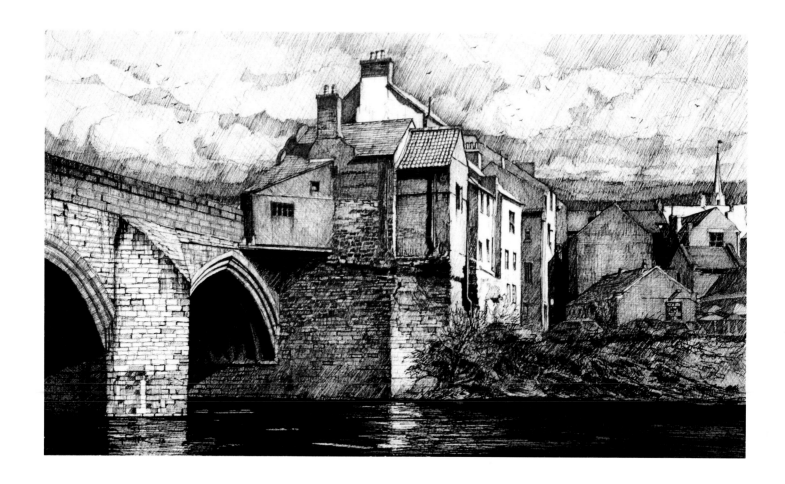

Elvet Bridge

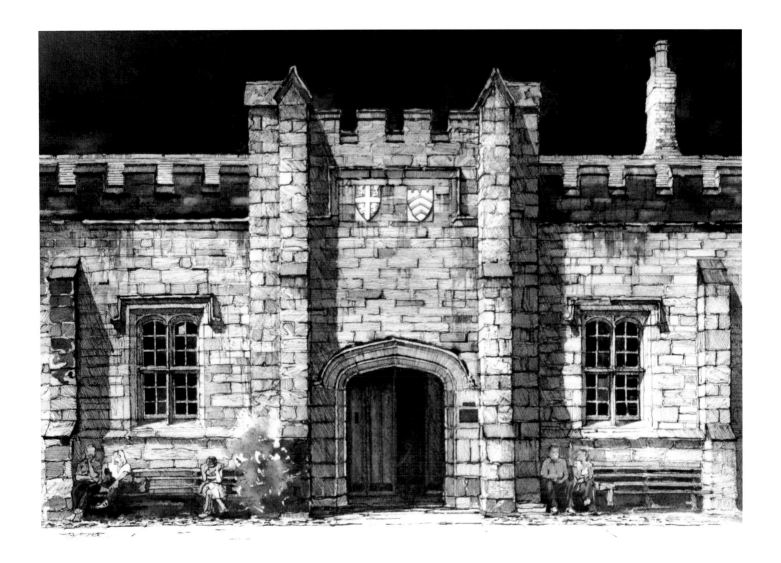

University Library

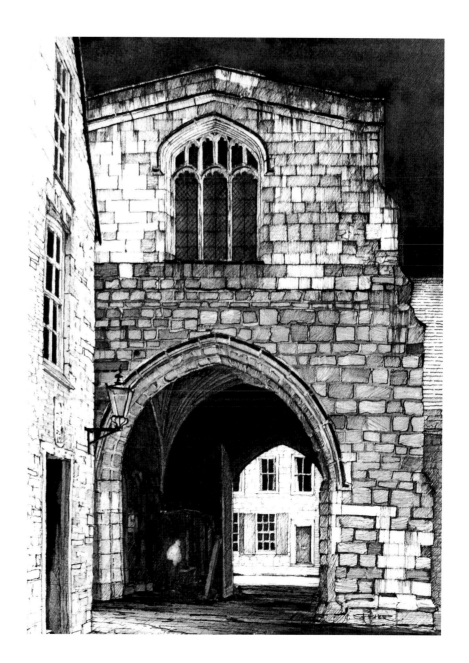

The Arched Gateway to The College
This picture offers a view through to the Bailey.

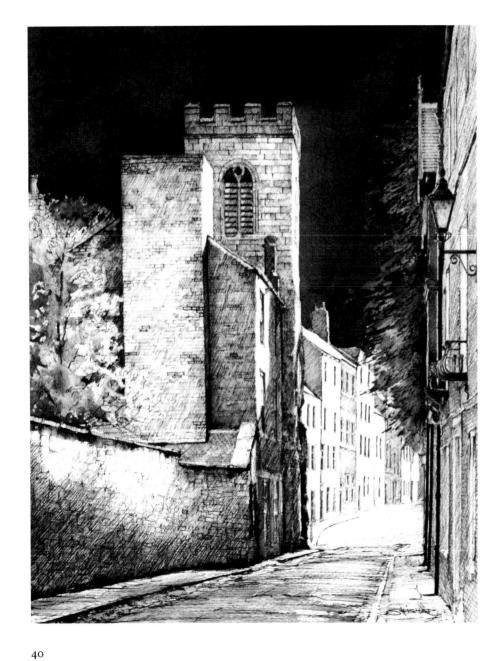

North Bailey Looking South

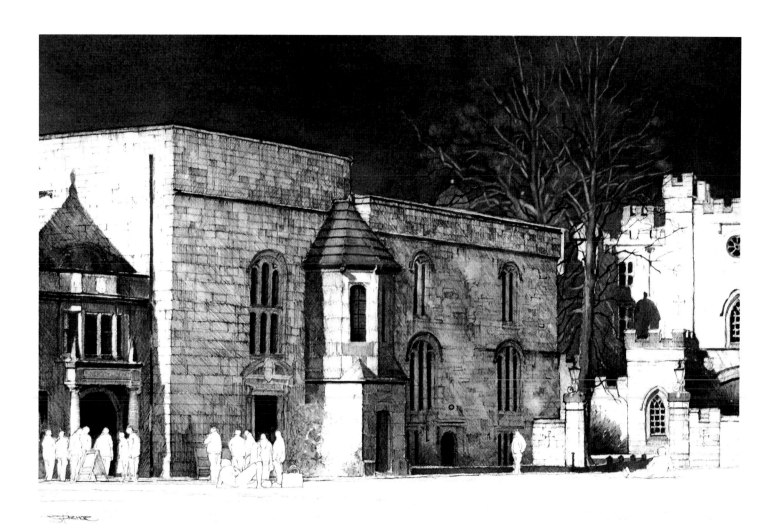

University Buildings on Palace Green

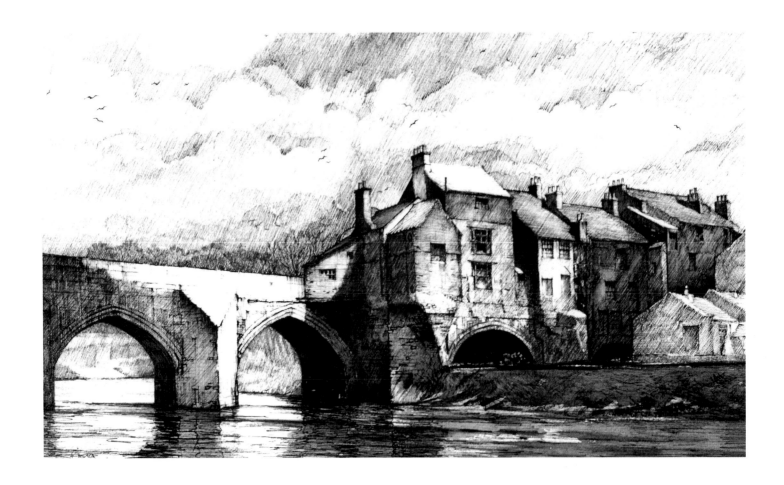

More Than Shadows
Elvet Bridge. An architect friend, on seeing this picture for the first time, confessed that he "couldn't possibly live with a painting so sinister".

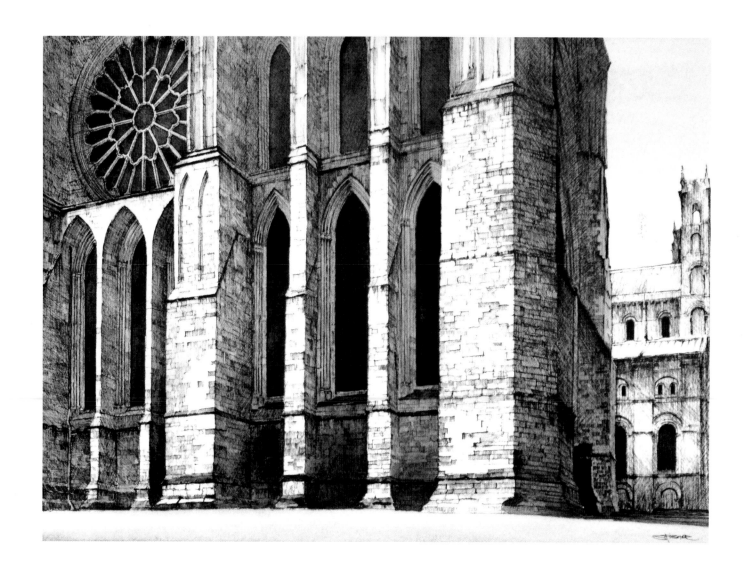

The Nine Altars

In reality this view is actually obscured by trees. The towers of the north transept would therefore not be visible as shown without the judicious application of "artistic licence".

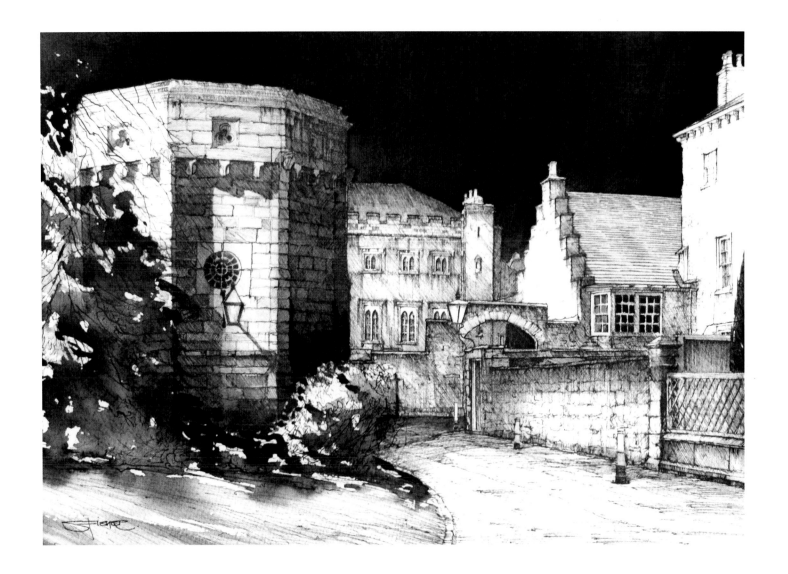

The College
The ancient water tower is in the foreground with the arched entrance to the Chorister School behind.

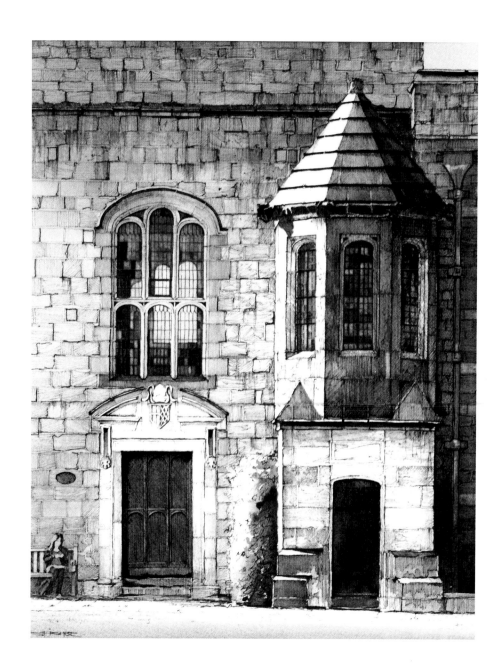

University Library Buildings,
Bay Window Detail
*This interesting bay window forms part
of the university buildings on Palace
Green. The deep sepia tones are to
me eminently effective in representing
the nature of ancient stonework.*

Out and About

A selection of subjects from around the United Kingdom, some of which are local to County Durham.

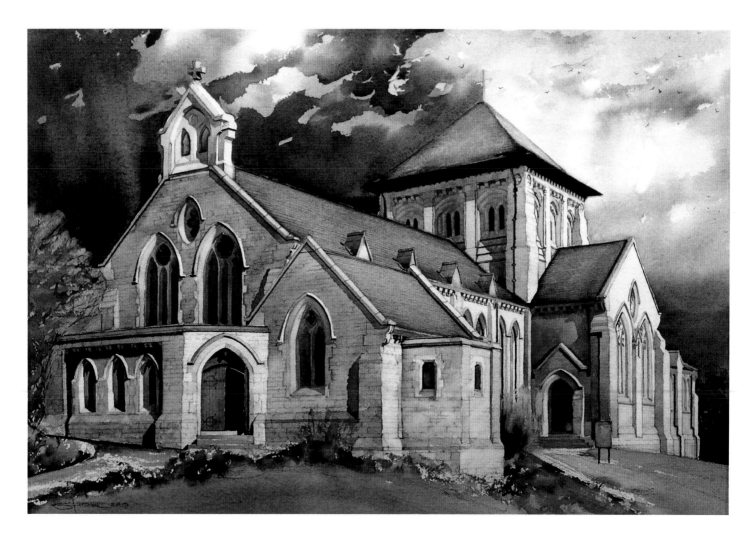

St Mary's Church, Horden: "The Miners' Cathedral"

This commissioned painting was produced to celebrate the church's centenary in 2013. The mineowner who built it is said to have forbidden the extraction of coal from the seams beneath its foundations. The stone-clad exterior belies the fact that the interior is made primarily of brickwork, the overall effect being that the church exudes a masculine toughness, well suited to its local name. The painting was unveiled after a special church service by the Bishops of Jarrow and Beverley.

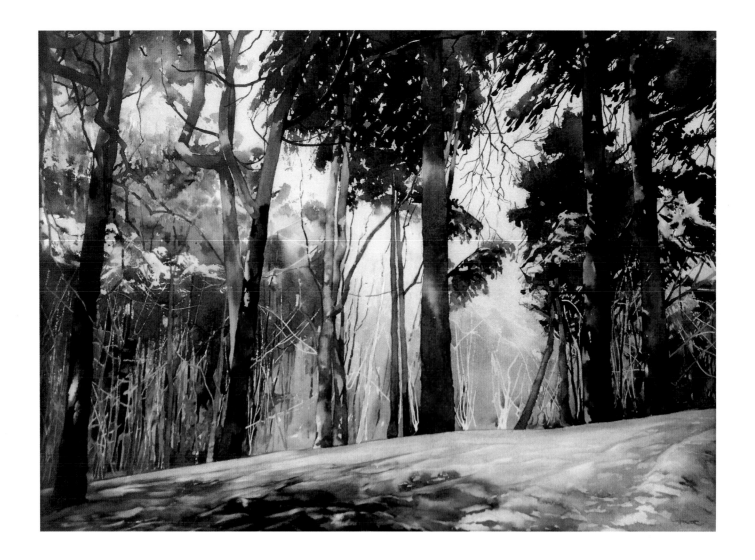

Pine Woods after Snow
The woodland to the rear of our house in Peterlee is part of the Castle Eden Dene nature reserve, managed by Natural England. It has been a source of pleasure and inspiration for many years.

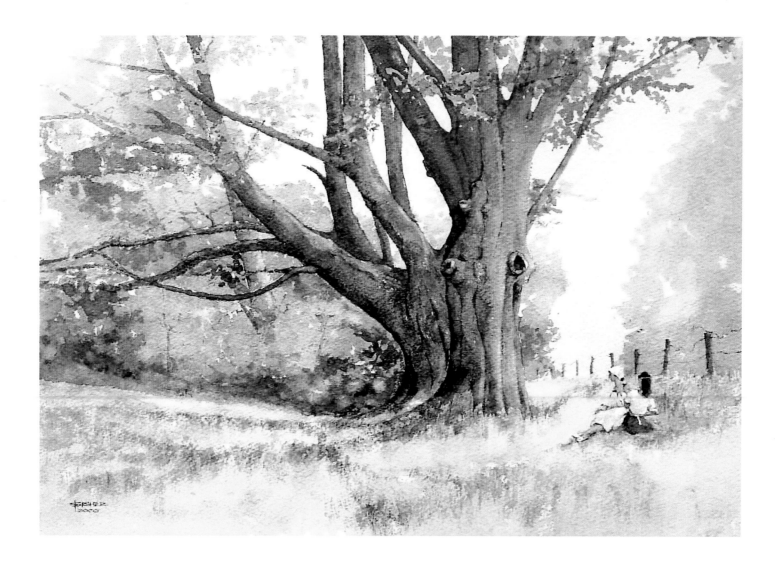

Repose

These huge beech trees lie, as in the previous image, just over our back fence. In this and the following painting, I couldn't resist including a couple of figures in honour of perhaps the greatest watercolour painter of all time, Sir William Russell Flint.

49

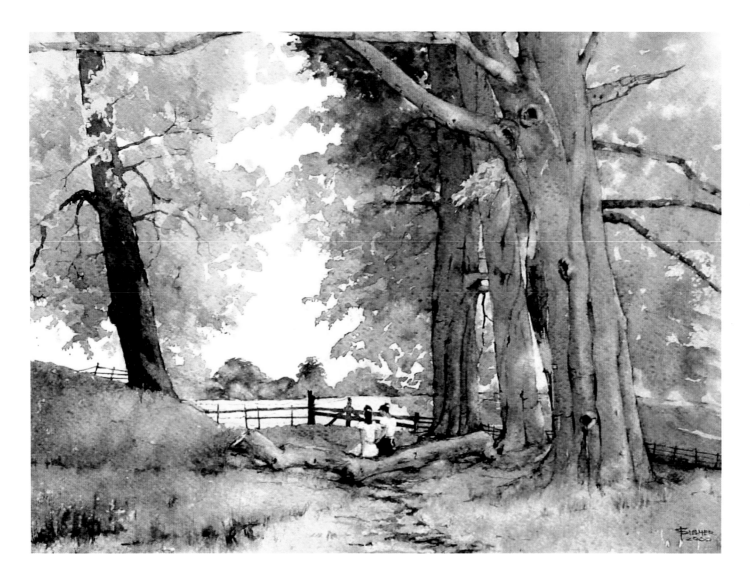

Glade

Both this and the previous painting were created outside, the figures being added later.
This one features a view over the golf course at nearby Castle Eden.

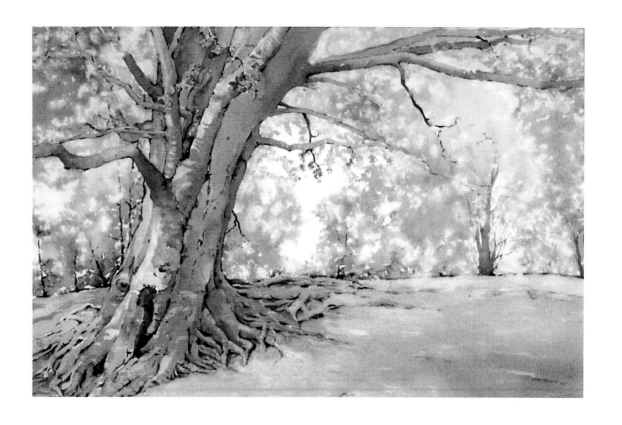

Old Man of the Woods
Another huge beech tree over our back fence. Painting in situ *sitting on a flimsy picnic chair, I fell
backwards down the slope on more than one occasion before it was completed!*

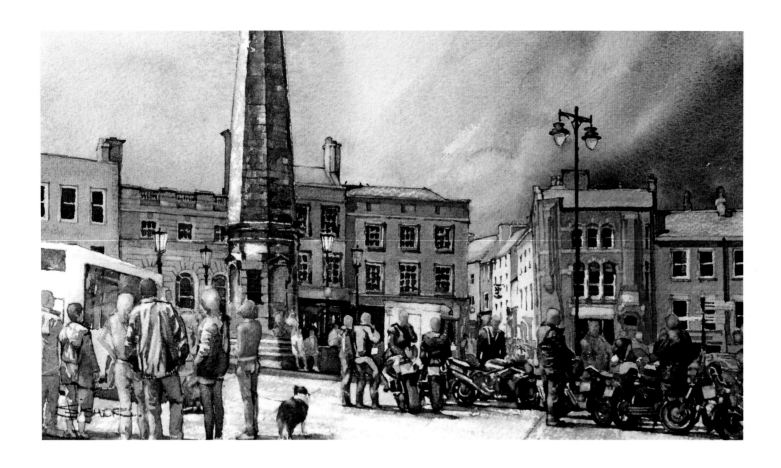

Richmond Market Place, North Yorkshire
A magnet for bikers and tourists alike.

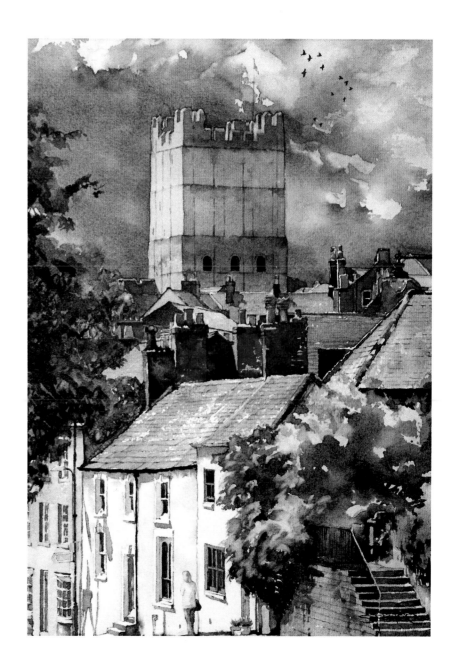

Richmond Castle

In this painting, the thirty metre high keep of Richmond Castle is seen towering over the mainly Georgian buildings below. The keep was used to imprison conscientious objectors during the First World War.

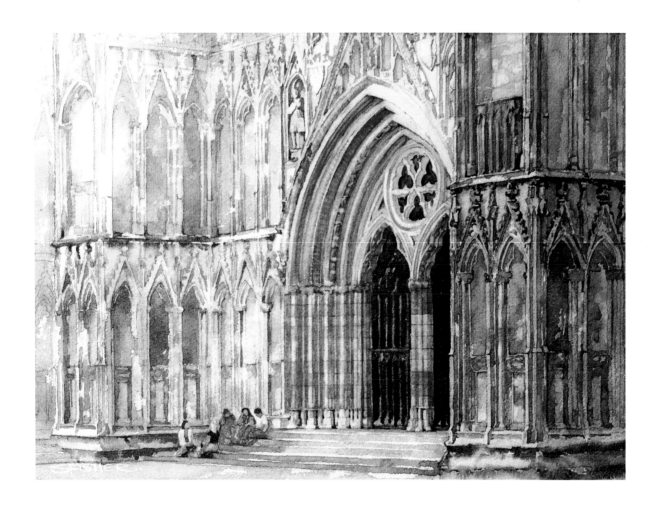

The West Door of York Minster
The Minster is the seat of the Archbishop of York, the second most senior bishop in the Church of England.

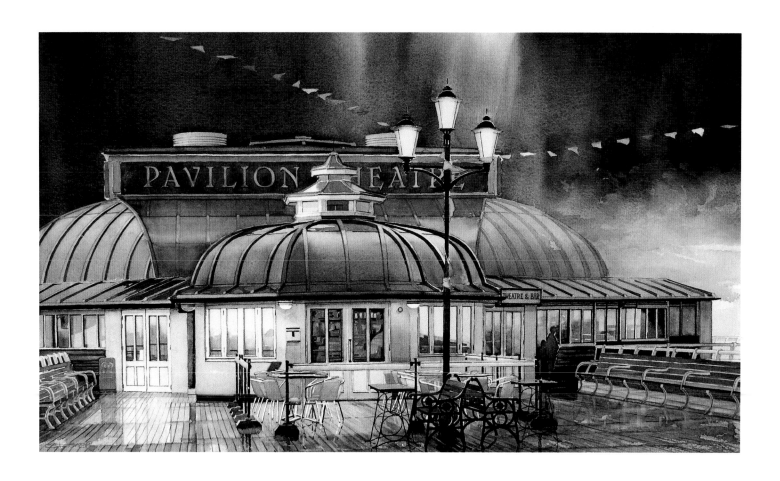

And Day Became Night
I was delighted to be shortlisted as a finalist in the 2013 Sunday Times Watercolour Competition. The painting depicts a violent storm breaking over Cromer pier in Norfolk. Anne and I were literally soaked through to the skin in the ensuing deluge of rain.

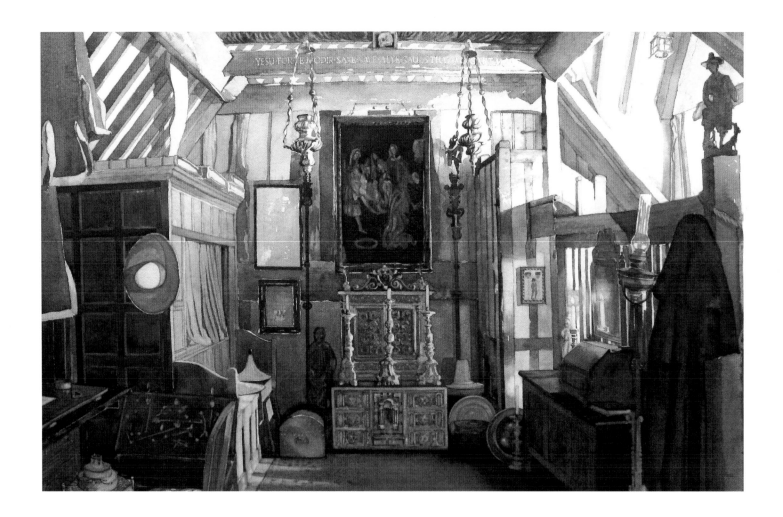

The Collector's Retreat

Snowshill Manor (National Trust). This painting is of the attic bedroom of Charles Paget Wade, an extraordinary man with an almost uncontrollable passion for collecting. He decanted to the attic of one of his stone outbuildings when his beautiful manor house was bursting at the seams. I am guessing that the painting in the centre of the composition is by or after the famous Dutch engraver and painter, Lucas Van Leyden (1494–1533). Wade's bed is to the left of the picture, behind the drawn curtains.

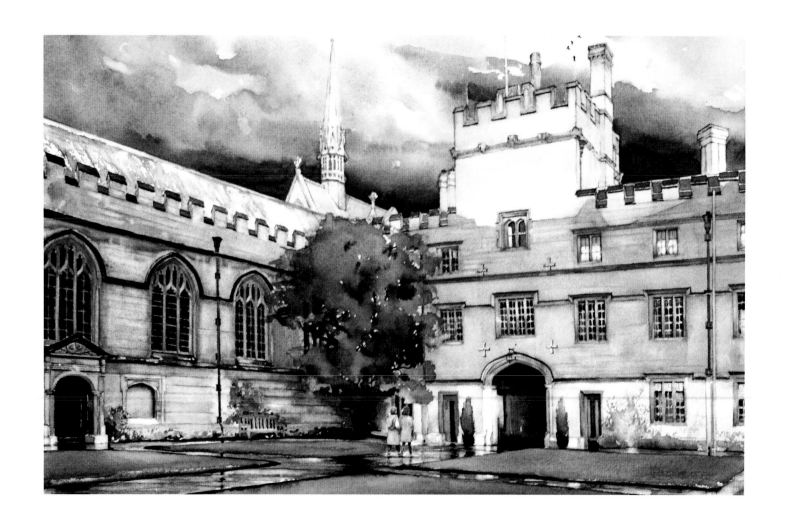

The Outer Quad of Jesus College, Oxford

For this 2012 commission, I spent three days in Oxford waiting for appalling October weather to allow some sunlight to penetrate the gloom. Thankfully, it obliged on the very last day, and this was, to my eye at least, the satisfying result.

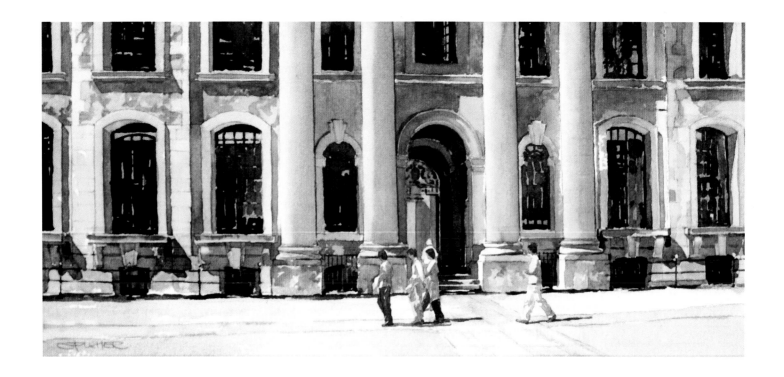

The Clarendon Building, Oxford
One of the jewels in Oxford's crown, the Clarendon was designed by Nicholas Hawksmoor and built between 1711 and 1713 to house the University Press. The building lies adjacent to the Sheldonian Theatre, shown opposite, which was designed by Hawksmoor's mentor and tutor, Sir Christopher Wren.

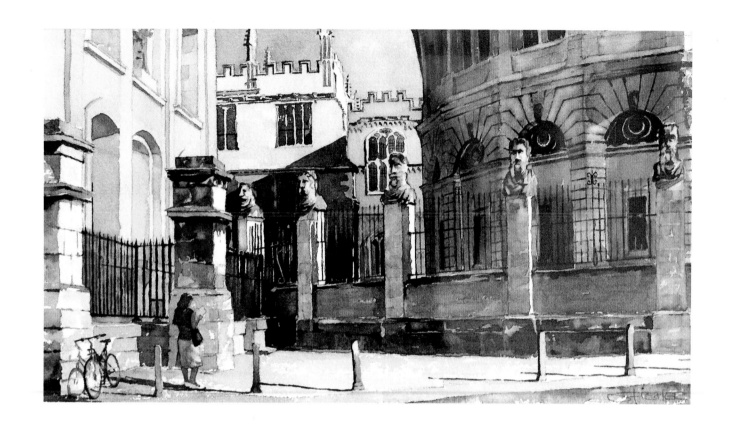

The Sheldonian, Oxford
Wren's Sheldonian Theatre was commissioned by Gilbert Sheldon, Archbishop of Canterbury, and was constructed between 1664 and 1669. It is the official ceremonial hall of the University of Oxford.

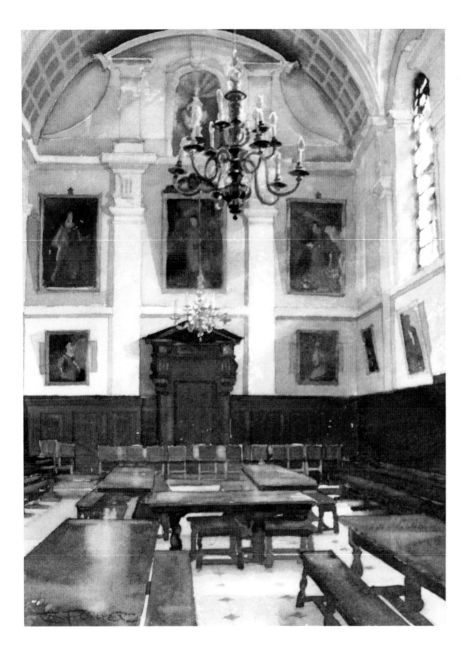

The Queen's College, Oxford
The magnificent hall of The Queen's College dates back to the eighteenth century. Notable alumni, some of whom have their portraits adorning the walls, include Edmund Halley, Tim Berners-Lee, and Rowan Atkinson.

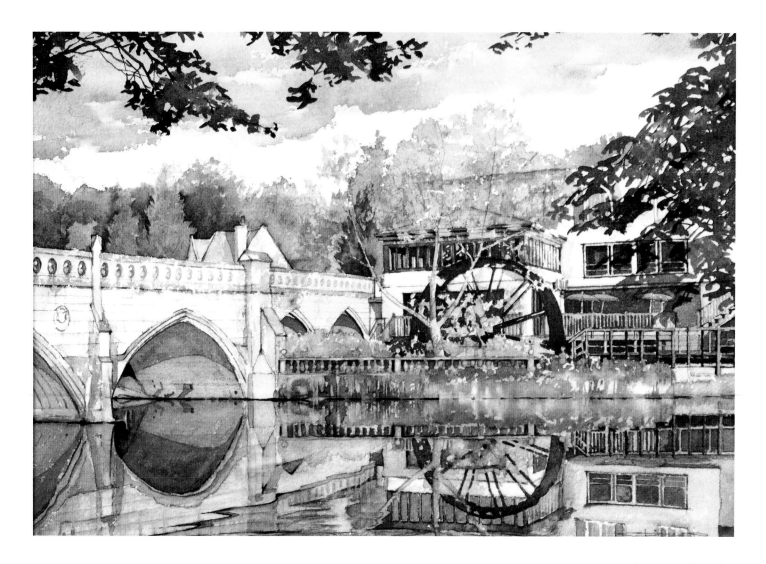

Batheaston Toll Bridge

This charming nineteenth-century bridge spanning the Avon lies three miles from the centre of Bath and is possibly one of only two still in use today where the collection of tolls is allowed by Royal Decree to be free from taxation. The adjoining Old Mill Hotel, a particular favourite of Anne's and mine, is built into one of the arches and features a purely decorative cast iron wheel.

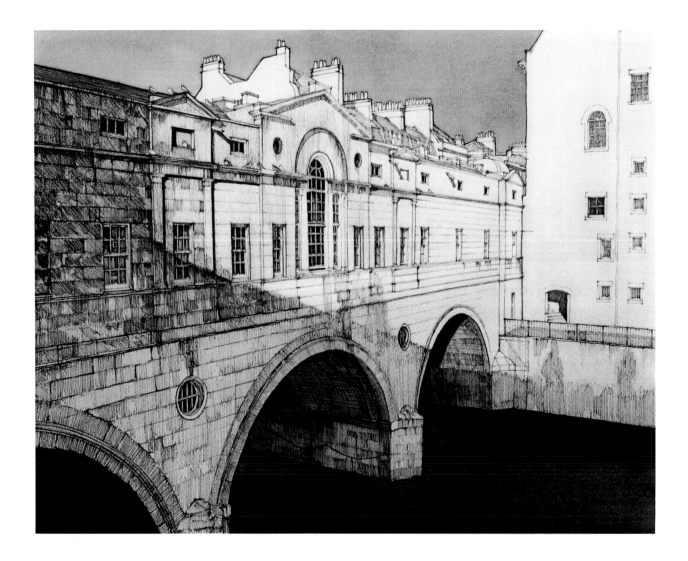

Pulteney Bridge, Bath

Spanning the River Avon in the centre of Bath, Pulteney Bridge, designed by Robert Adam, was completed in 1773. It is one of only four bridges in the world having shops across the full span on either side of the bridge thoroughfare.

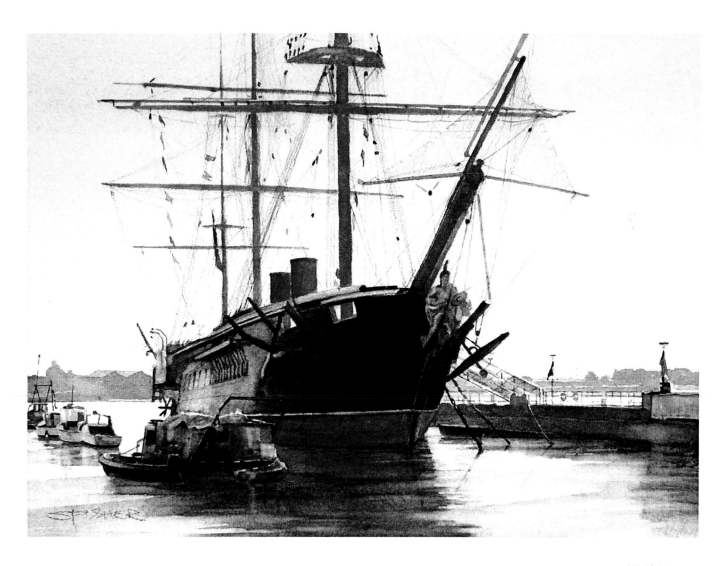

HMS Warrior

The ironclad Warrior, when launched in 1860, was the most powerful ship in the Royal Navy. However, she was superseded after only ten years by a new class of mastless warship and never saw action in active service. In 1979 she was towed to a temporary home in Hartlepool for restoration, which was completed in 1987. This painting depicts the ship on display in Portsmouth Historic Dockyard.

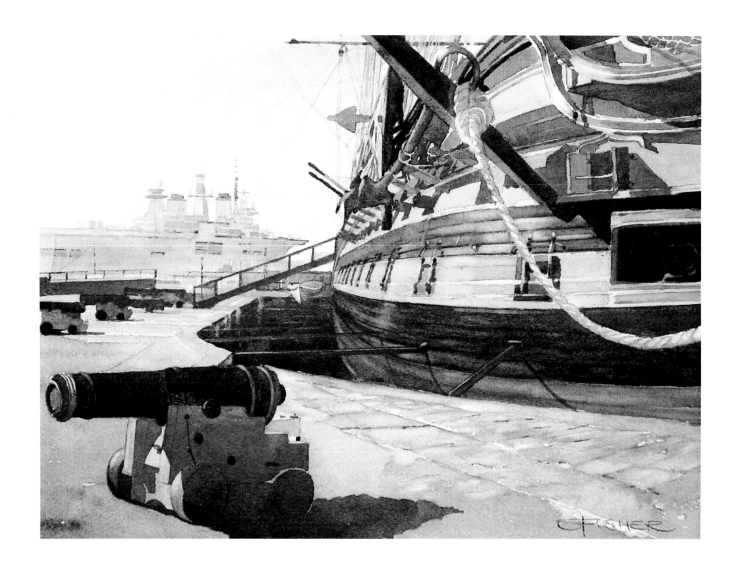

HMS Victory

Victory, launched in 1765, was Nelson's flagship at the Battle of Trafalgar in 1805 and lies in dry dock in Portsmouth Historic Dockyard.

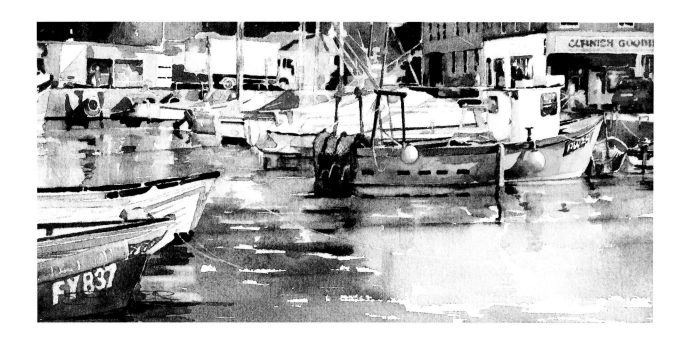

Cornish Goodies

A view of Mevagissey Harbour. Once a centre of smuggling, Mevagissey is now one of Cornwall's most popular tourist destinations.

Further Afield

A selection of paintings from Italy.

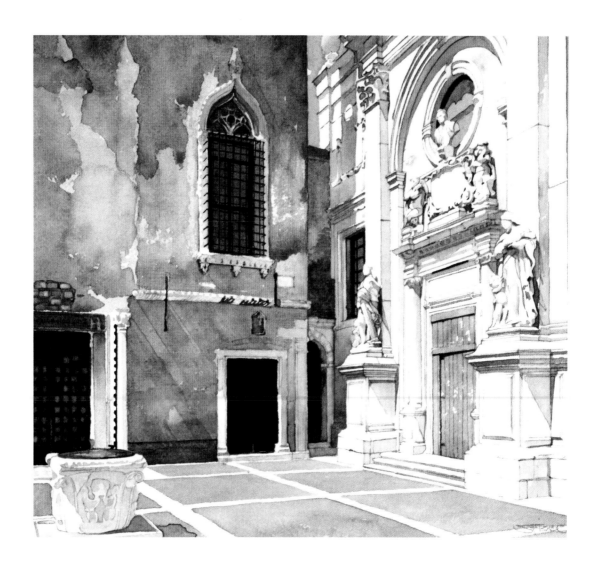

The Church of Santa Maria Misericordia, Venice

This often-overlooked Venetian church, lying in the Sestiere of Cannaregio, was founded in the tenth century. It is situated on one of the main waterways into the city, used by motor launches for delivering tourists to and from the airport.

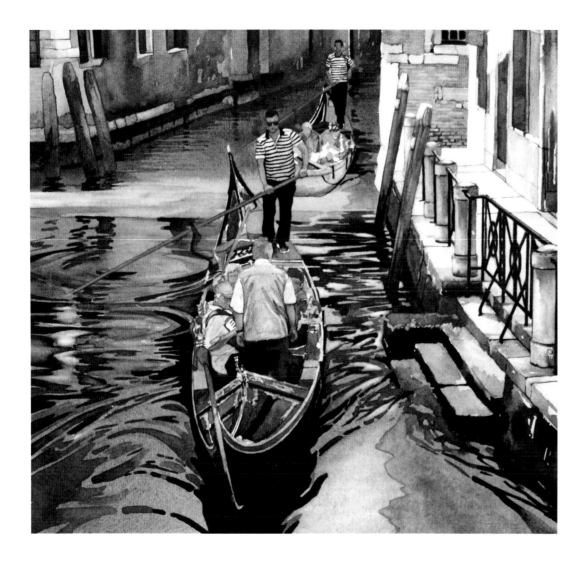

Venetian Serenade

The side canals of Venice are, more often than not, packed bow-to-stern with gondolas ferrying tourists around the city. In this painting, the passengers of the gondola in the foreground are being entertained by a singer and his accordionist.

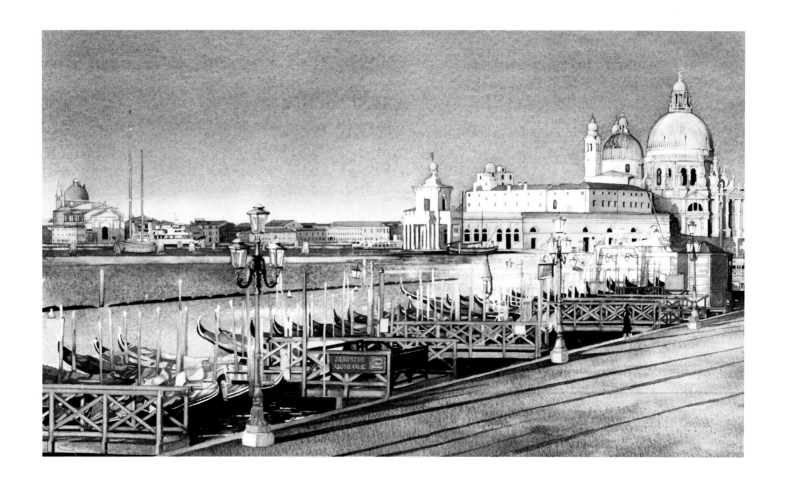

Gondola Stations

An early morning view of the many gondola stations adjacent to Piazza San Marco, rarely observed without the tourist hordes.

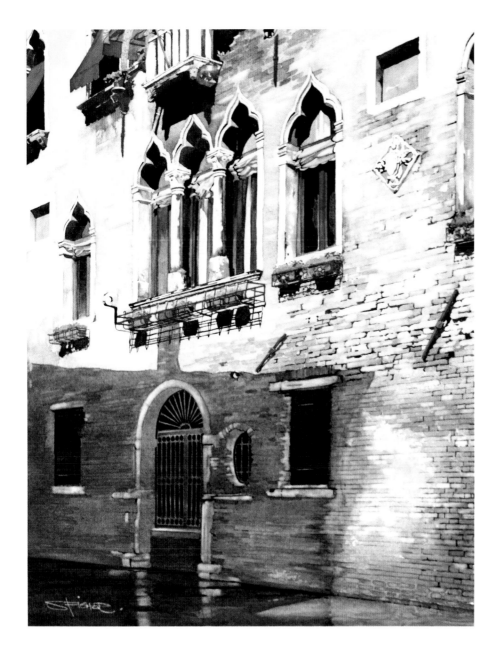

Palazzo on a Venetian Canal
This distressed facade adds to the charm of one of the many palazzi to be found in Venice.

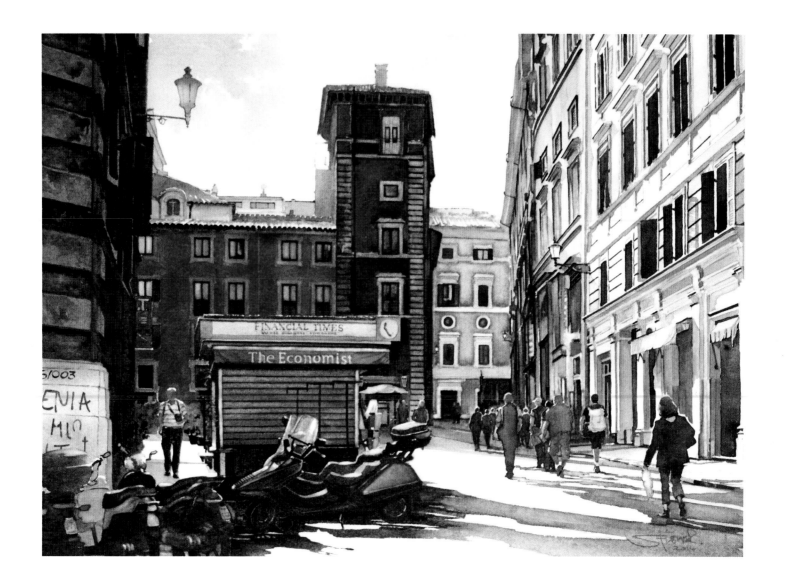

A Street in Rome

Just around the corner from the world-famous Pantheon, residents and tourists stream back to their accommodation as evening light fades.

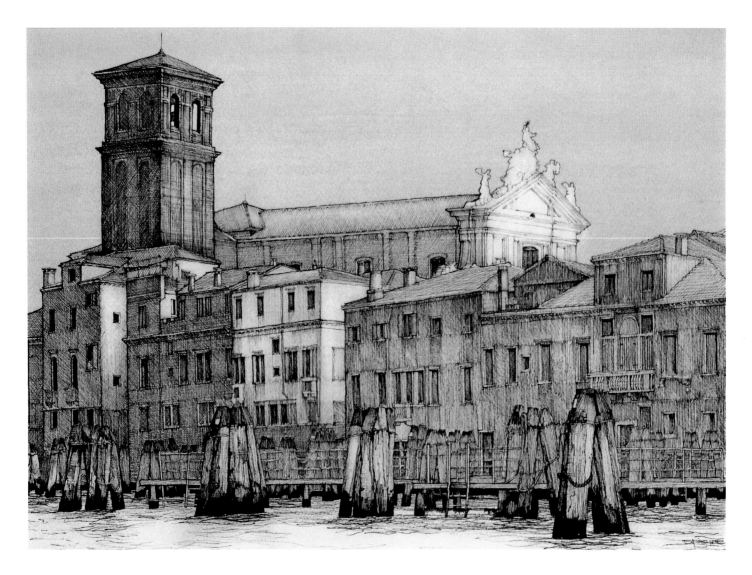

The Church of Santa Maria Assunta, Venice
The baroque church commonly known as "Gesuiti" is said to be the work of Giovanni Battista Fattoretto and was constructed between 1715 and 1730. The large staves driven into the silt demarcate the channels used by surface craft plying their trade around the lagoon.

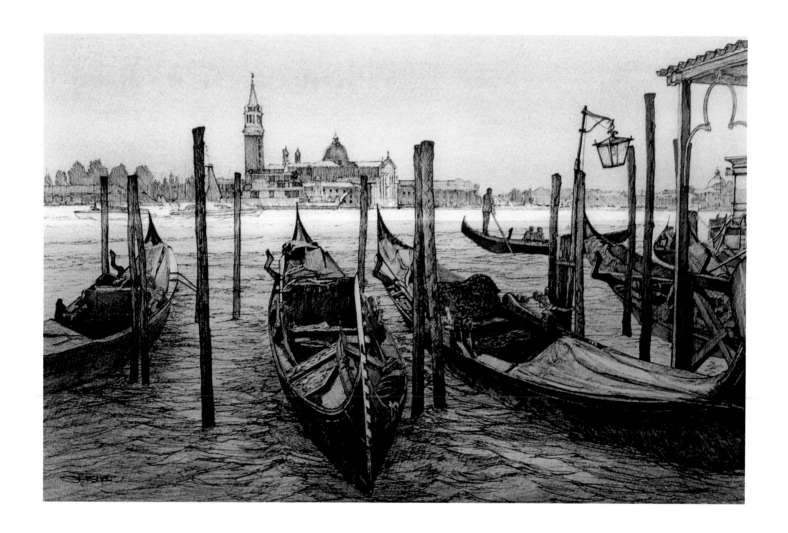

The Gondola Station

San Giorgio Maggiore, the sixteenth-century Benedictine Basilica, is viewed from one of the numerous gondola stations serving tourists visiting Piazza San Marco. The church was designed by Andrea Palladio and built between 1566 and 1610 in the classical renaissance style.

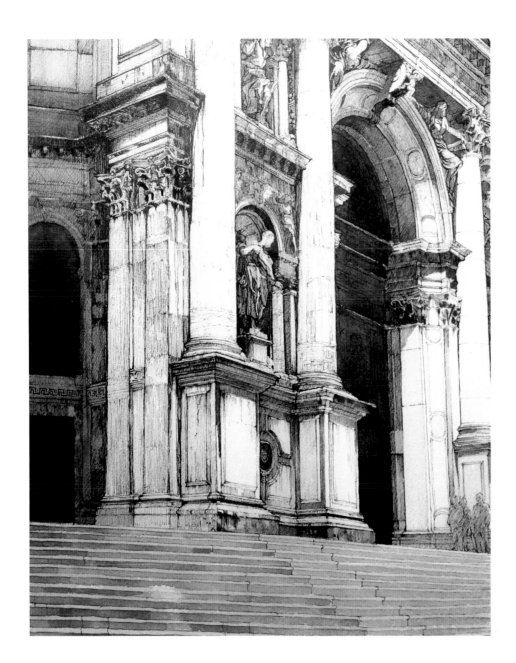

Basilica Santa Maria Salute, Venice
The Basilica of St Mary of Health, commonly known as "Salute", is actually a minor basilica standing on a finger of land between the Grand Canal and the lagoon, making the church visible from the Piazza San Marco. The church was designed in the baroque style by Baldassare Longhena, and construction began in 1631. The dome of the Salute was an important addition to the Venetian skyline and soon became a city icon, inspiring artists such as Canaletto, Turner, and John Singer Sargent.

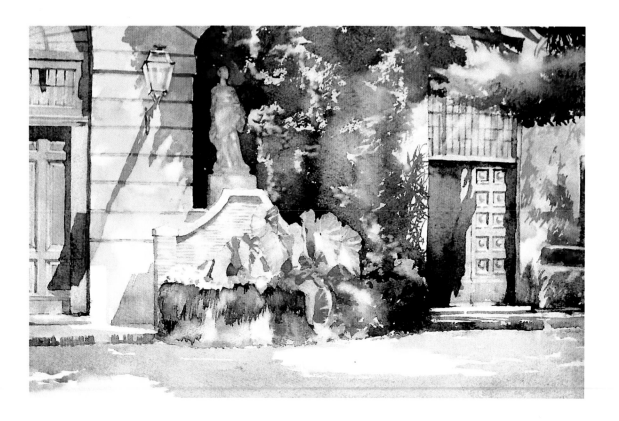

Roman Oasis

A number of years ago, whilst on a short break to Rome, we were walking from the Spanish Steps towards
Piazza del Popolo. Poking my head through a half-closed doorway, this is what I saw.